DEATH

First published 2023 by order of the Tate Trustees by Tate Publishing,
a division of Tate Enterprises Ltd, Millbank, London SW1P 4RG
www.tate.org.uk/publishing

A catalogue record for this book is available from the British Library
ISBN 978 1 84976 865 8

Distributed in the United States and Canada by ABRAMS, New York

Library of Congress Control Number applied for

Senior Editor: Alice Chasey
Series Editor: James Finch
Production: Roanne Marner
Picture Researcher: Roz Hill
Designed by Narrate + Kelly Barrow
Colour reproduction by DL Imaging, London
Printed in Wales by Cambrian Printers

Front cover: Francis Bacon, *Triptych August 1972* 1972 (detail of centre panel,
see p.22)

Measurements of artworks are given in centimetres, height before width,
before depth.

DEATH

SEAN BURNS

Director's Statement

'Look Again' is a bold new publishing programme from Tate Publishing and Tate Britain. In these books, we are providing a platform for some of the most exciting contemporary voices writing today to explore the national collection of British art in their own way, and reconnect art to our lives today. The books have been developed ahead of the rehang of Tate Britain's collection, which foregrounds many of the artworks discussed here. In this third set of books – *Death* by Sean Burns, *Strangers* by Ismail Einashe *Girlhood* by Claire Marie Healy, and *Faith* by Derek Owusu – we are offered unique perspectives on a wide range of artworks across British history, and encouraged to look closely, and to look again.

Alex Farquharson, Director, Tate Britain

When I was asked to write this personal guide to works from the Tate collection, I had just lost someone close. I'm still grieving them but, over the intervening weeks, I've shifted those initial emotions – guilt, sadness, remorse – around my body to somewhere more settled and less distracting. But you never truly 'get over' a loss because it's permanent.

On a visit to Tate Britain in the early days of my grief, I could feel a shallow, disorientating sensation in my chest and stomach. Indeed, all I could see, it seemed, was the way death haunted the gallery's collection – from Gavin Jantjes's print *Dead* 1974–5, which uses the guise of a children's colouring book to comment on the atrocities of South African apartheid, to Edward Collier's murky *Still Life* 1699, a vanitas painting laced with *memento mori* indicating that time is passing. In fact, the more I looked, the more I realised that the universality of death in art was merely a reflection of its universality in life. By tapping into our core fears, works in which mortality or loss are the central tenets activate our deeper consciousness. Which is to say: art about death often makes us feel more alive.

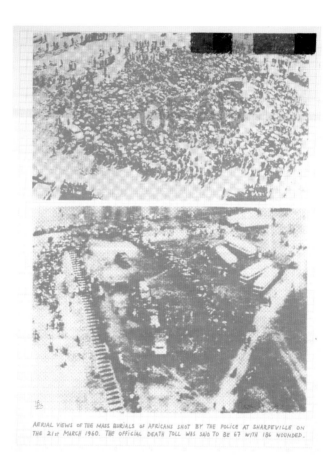

AERIAL VIEWS OF THE MASS BURIALS OF AFRICANS SHOT BY THE POLICE AT SHARPEVILLE ON THE 21st MARCH 1960. THE OFFICIAL DEATH TOLL WAS SAID TO BE 67 WITH 186 WOUNDED.

Gavin Jantjes, *Dead* 1974–5, screenprint on card, 60.2 x 45.2, Tate

Edward Collier, *Still Life* 1699, oil paint on canvas, 76.2 x 63.5, Tate

In this text, I trace an erratic route through Tate Britain, underscoring how artists have portrayed death in three ways: allegorically, as a symbolic presence; collectively, as a tool for justice; and intimately, as a reflection of personal loss. What do these artworks reveal about the social conditions under which they were produced? What were the artists' motivations? How has death emerged as such a persistent theme in art history? The nature of artmaking isn't as clean-cut as these three categories suggest, of course: works of art are the product of multiple influences. I'm interested in the incidental connections between things, especially when they are grouped under the rubric of a 'national collection', with its implicit ambition to represent the art of an entire country. For me, art is not a means by which to consolidate a solid argument but a point from which complex notions – justice, love, memorialisation, power – can evolve.

Two works in the collection bear the same foreboding title: *Electric Chair*. Andy Warhol's 1964 screenprint depicts the sort on which murderers fry; Mohammed Sami's 2020 painting is an ornate golden throne with royal-blue upholstery, imbued with a sense of silence. Sami's oblique paintings derive from his memories of living under Saddam Hussein's regime in Baghdad, Iraq. Obfuscations of trauma after the fact, his stark images linger in the memory, inviting us to think

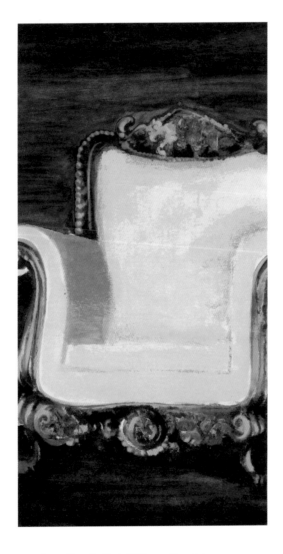

Mohammed Sami, *Electric Chair* 2020, acrylic paint on canvas,
170 x 90, Tate

about where the nexus of power and influence truly resides. His *Electric Chair* reminds us that the violent decision to take a life in the name of justice occurs elsewhere than the site of death itself. While Warhol was interested in how repetition and exposure altered our relationship to violent imagery, Sami looks for insidious violence in residual places, the close crop of the image extending its strangeness. 'As an artist, when you're a first-hand witness to extreme events, you need a strategy to slow down the stereotypical image of trauma and conflict in your work,' he noted in a recent interview. 'Otherwise, you may end up being a reporter or mimicking the collective memory.'[1] How should artists approach image-making in a world that contains so much visual material? How best to represent and retain the complexity of traumatic subject matter?

Francis Bacon was also inclined to repeatedly depict images of violence. Painted after the horrors of the Second World War, at a time when notions of representation were being blown apart, his famous triptychs give an impression of a series of events unfolding – although not necessarily in chronological order. Bacon's fascination with the photographer Eadweard Muybridge is well documented, and the seriality of his canvases in some way borrows from Muybridge's studies of bodies and beasts in motion,

"HOW SHOULD ARTISTS APPROACH IMAGE-MAKING IN A WORLD THAT CONTAINS SO MUCH VISUAL MATERIAL? HOW BEST TO REPRESENT AND RETAIN THE COMPLEXITY OF TRAUMATIC SUBJECT MATTER?"

such as *Animal Locomotion* (1887), copies of which were found in Bacon's Kensington studio after his death.

When Bacon's lover George Dyer – a crook with a burly exterior and introverted interior – took his life in a Parisian hotel room two days before the artist's career-crowning retrospective opened at the Grand Palais in 1971, Bacon suppressed the news until the vernissage. And, given his stoicism – the critic John Russell described it as on a level 'to which only few could aspire'[2] – we might read Bacon's *Black Triptychs* 1972–4 as an articulation of personal grief that the artist found difficult to express in meatspace. Later in life, Bacon found it increasingly challenging to depict the dead, telling the critic and

"NO ONE COULD PAINT A QUOTIDIAN OBJECT SUCH AS A DOORKNOB OR A U-BEND LIKE BACON; EQUALLY, NO ONE COULD TEAR AWAY THE VENEER OF POLITE SOCIETY TO REVEAL THE CARNALITY AND CRUELTY THAT LURKS WITHIN AUTHORITY AS HE DID."

curator David Sylvester in 1979, 'It's always more difficult – or seems more difficult to me – to do heads of people who are dead.'[3]

Bacon was an exceptional stylist and an underrated colourist. Unfortunately, interpretations of his work often get lazily caught on words like 'gruesome' and 'contorted'. Truthfully, a lot of his painting is about gay sex – not, however, these images. Here, he is empathically channelling, reliving, the final moments of his lover's tragic demise in Paris, France, following a barbiturate overdose. In *Triptych May–June 1973* 1973, Bacon used small arrows pointed at Dyer to evoke the sense of a crime scene photograph: here,

as elsewhere, Bacon's paintings depict a battle between precise, almost architectural composition, redolent of his time as an interior designer, and his figures' choreographed chaos and close-knit frenzied brushwork. No one could paint a quotidian object such as a doorknob or a U-bend like Bacon; equally, no one could tear away the veneer of polite society to reveal the carnality and cruelty that lurks within authority as he did.

The triptych as a form first appeared in Western art during the Middle Ages, adorning the altarpieces of churches. Bacon was influenced by religious art, such as Jan and Hubert van Eyck's twelve-panel *Ghent Altarpiece* 1432, and in *Triptych August 1972* 1972, he depicts Dyer – a gay, small-time gangster – in the manner of a divine Christian altarpiece; Bacon's insistence on gilt framing only adds to the work's reverent appearance. The empty throne in Sami's *Electric Chair* isn't dissimilar to the one on which the Pope sits in Diego Velázquez's *Portrait of Innocent X* c.1650, an image that Bacon would combine with the screaming nurse from Sergei Eisenstein's *Battleship Potemkin* (1925) in his 1953 masterpiece *Study after Velázquez's Portrait of Pope Innocent X*. In Eisenstein's film, the nurse shrieks as a baby in a pram tumbles down the Odessa Steps in Ukraine, before a splash of blood appears in her circular pince-nez.

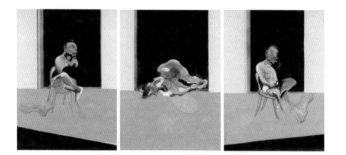

Francis Bacon, *Triptych August 1972* 1972, oil paint and sand on three canvases, each 198.1 x 147.3, Tate

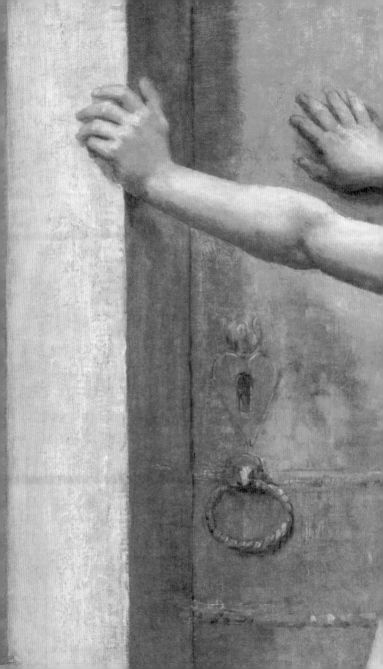

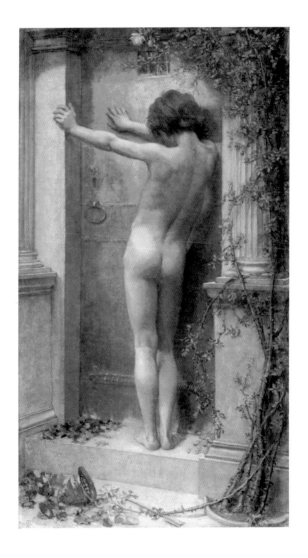

Anna Lea Merritt, *Love Locked Out* 1890, oil paint on canvas,
115.6 x 64.1, Tate

"CUPID HAS CAST ASIDE THE ACCOUTREMENTS OF HIS DAY JOB – THE ARROW AND THE LANTERN – TO DEDICATE HIMSELF TO MOURNING"

Like Bacon, Anna Lea Merritt was also motivated by love and its loss: her husband, Henry, died only a few months after their wedding. In *Love Locked Out* 1890, Merritt depicts Cupid, the god of desire, feebly attempting to access Henry's tomb: the cherub presses a gentle hand against the door, longing for a reunion. Cupid has cast aside the accoutrements of his day job – the arrow and the lantern – to dedicate himself to mourning, while allegorical thorns surround him, evoking the pain and persistence of love. Although the patriarchal mores of the time deemed it inappropriate for women to portray nudity, Merritt avoided controversy by depicting a child rather than an adult. The paradox is that, had Henry lived, Merritt would have been societally obligated to relinquish

painting and end her career; instead, she continued working until her death in 1930.

Whereas Bacon and Sami's works contain, in different ways, a search for truth, Merritt and the Pre-Raphaelites – a brotherhood of artists seeking to return to the quattrocento style of painting of the pre-High Renaissance period – were concerned with fantastical and romantic interpretations of death. Of these, perhaps none is better known than John Everett Millais's *Ophelia* 1851–2, a detailed rendering of the character's drowning in William Shakespeare's *Hamlet* (1601).

Three years later, while on honeymoon in Scotland in 1855, Millais conceived of a painting of two suspicious and exhausted-looking nuns digging a grave as night falls. It certainly seems revealing that the artist regarded the resulting work, *The Vale of Rest* 1858–9, as his favourite. Yet Millais was working in a Victorian society in which mortality was so omnipresent that codes of mourning – widows grieving for two years; children wearing full black for a year after the death of a parent or sibling – were strictly observed and a preoccupation with the supernatural, mythological and folkloric abounded. *The Vale of Rest* depicts one nun seated to the right of the frame counting rosary beads, while the second shovels earth out of a grave in

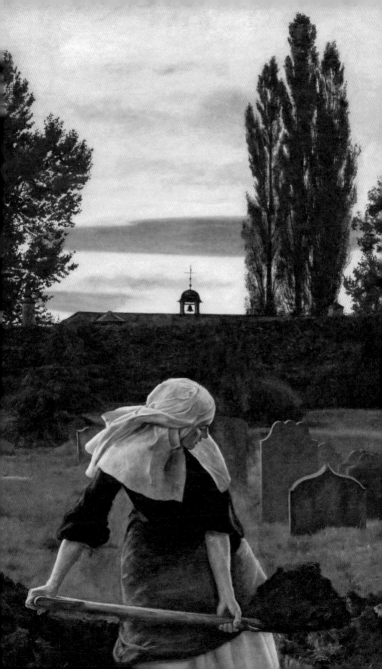

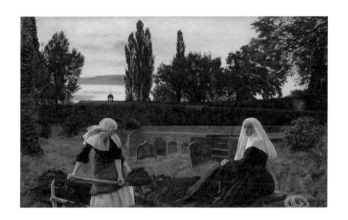

John Everett Millais, *The Vale of Rest* 1858–9, oil paint on canvas,
102.9 x 172.7, Tate

"THE PICTURE CAN BE READ AS A CYCLE –
BIRTH, MARRIAGE, DEATH – WITH THE MAN THE
UNDOUBTED CENTRE OF THE ACTION."

apparent haste. The painting is so unusual and gothic that it's hard to believe the same hand produced its pendant, *Spring* 1859, in which a party of young women take refreshments in front of a blossoming apple orchard.

Despite carrying none of the foreboding of Millais's nuns nor the torment of Bacon's triptychs, David Des Granges's *The Saltonstall Family* c.1636–7 is a beautifully literal representation of loss. Sir Richard Saltonstall pulls back the red drapes of a four-poster bed in which his first wife, Elizabeth Basse, dressed entirely in white, lies dead. Beside the bed sits his new wife, Mary Parker, swaddling a young baby with very knowing, black eyes, while Saltonstall's two elder children, Richard and

Ann, presumably mourning their mother, hold hands behind their father, peering into the middle distance. The picture can be read as a cycle – birth, marriage, death – with the man the undoubted centre of the action. Despite its prosaicism, however, the painting communicates very clearly one of the real-world consequences of loss: motherless children. *The Saltonstall Family* is one of my favourite works in the Tate collection because its temporal collapse is so odd. Here, time is condensed, with the elder children's mother a continuing, spectral presence in their new family unit.

In a departure from his more usual paintings of decrepit abbeys or boats on misty horizons, Joseph Mallord William Turner's *The Fall of Anarchy* c.1833–4 is an apparition of a cadaver flopping from a disappearing white horse into an ocean of deep red and burnt umber. Academic Sam Smiles has posited that this painting is a reference to Percy Bysshe Shelley's *The Masque of Anarchy* (1832), a poem inspired by the Peterloo Massacre of 1819 in which fifteen protestors died after cavalry charged into a crowd of people who had gathered in Manchester to demand the reform of parliamentary representation:[4]

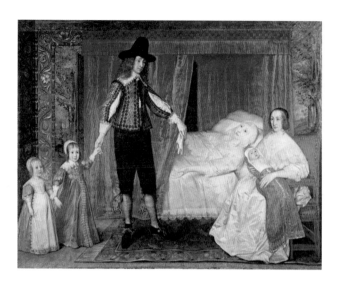

David Des Granges, *The Saltonstall Family* c.1636–7, oil paint on canvas, 214 x 276.2, Tate

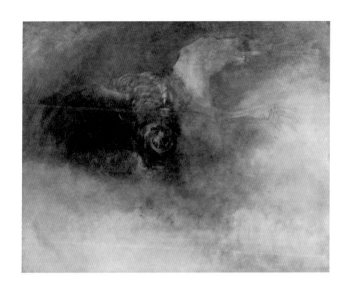

J.M.W. Turner, *The Fall of Anarchy* c.1833–4, oil paint on canvas, 77.6 x
94, Tate

Last came Anarchy: he rode
On a white horse, splashed with blood
He was pale even to the lips,
Like Death in the Apocalypse.

And he wore a kingly crown;
And in his grasp a sceptre shone;
On his brow this mark I saw –
'I AM GOD, AND KING, AND LAW!'[5]

Is Turner emphasising allyship with the victims of Peterloo? His Death isn't victorious or triumphant, but gilt-crowned and grotesque. And, unlike Des Granges's depiction of Elizabeth Basse – a polite, supernatural memorialisation of loss – Turner's Death emerges as a terrifying phantasmagorical rendering of one of the four horsemen of the apocalypse representing the horrors of injustice.

A similarly cataclysmic energy pervades Edwin Henry Landseer's spectacular *Deer and Deer Hounds in a Mountain Torrent* exh.1833, in which dogs, emerging almost elementally from craggy rocks, ravage their prey like a storm. The stag's convulsive eye rolls back into its skull as a hound's eager red tongue whips from its jaws. Celebrated for his anthropomorphised paintings of muscular beasts, which he brought to blood-pumping life through meticulously observed details such as

"... DOGS, EMERGING ALMOST ELEMENTALLY FROM CRAGGY ROCKS, RAVAGE THEIR PREY LIKE A STORM. THE STAG'S CONVULSIVE EYE ROLLS BACK INTO ITS SKULL AS A HOUND'S EAGER RED TONGUE WHIPS FROM ITS JAWS. "

fleshy gums and plaintive eyes, Landseer was commissioned to produce several works for Queen Victoria and, in 1866, sculpted the legendary lions at the base of Nelson's Column in Trafalgar Square, London.

One hundred and sixty-one years after *Deer and Deer Hounds in a Mountain Torrent*, Damien Hirst would portray a dead animal to very different ends. *Away from the Flock* is a helpless, fuzzy lamb petrified in formaldehyde, like something from the Natural History Museum. Death is Hirst's project, and he's been so successful as an artist because he understands its paradoxical mystery and universality. Here, the lone lamb becomes a conduit for our own reckoning with mortality because it

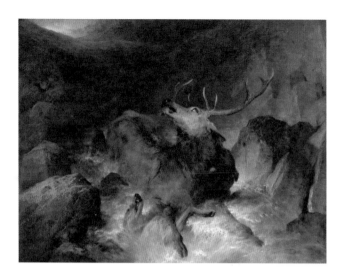

Edwin Henry Landseer, *Deer and Deer Hounds in a Mountain Torrent* (*'The Hunted Stag'*) exhibited 1823, 40.5 x 90.8, Tate

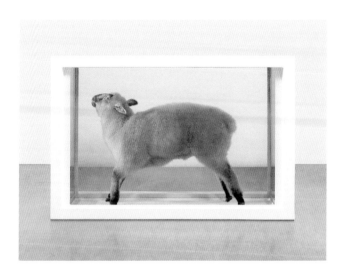

Damien Hirst, *Away from the Flock* 1994, glass, stainless steel, perspex, acrylic paint, lamb and formaldehyde solution, 96 x 149 x 51, Tate

confronts us with a once-living entity in purgatory – an idea Hirst never bettered than with the vast, suspended tiger shark in a tank of formaldehyde, aptly titled *The Physical Impossibility of Death in the Mind of Someone Living* 1991.

Deer and Deer Hounds in a Mountain Torrent and *Away from the Flock* are artificial scenes produced for different ends. Hirst collages ideas from art history: the tank originates in 1960s American minimalism and the liquid suspension draws from Jeff Koons's *Equilibrium* series of 1985, while the lamb is a Duchampian 'readymade'. It's a deliberately clinical exercise in art as experiential spectacle. Landseer's work, on the other hand, is emblematic of the Victorian fascination with the trappings and rituals of death, toying with ideas of the divine. In both instances, animals become a channel for human experience and death anxiety.

So, Tate Britain is not just full of death; it's full of paintings that exist only because of death. Throughout history, death has served as a pronouncement of the value of life. The production and exhibition of such work has functioned as a means of personal and collective grief and reckoning with loss, be it the death of a loved one or of a generation to conflict and war. The chronological rehang of the permanent collection

"THROUGHOUT HISTORY DEATH HAS SERVED AS A PRONOUNCEMENT OF THE VALUE OF LIFE. "

unveiled in 2012 made it easy to see how differently each artistic generation handled death: seventeenth-century painters, such as Des Granges and Collier, deployed poignant family portraits or foreboding *memento mori*, while the nineteenth-century Pre-Raphaelites loaded their ornate canvases with symbolism and stories of literary decline or dutiful heartbreak, as in the works of Millais and Merritt. Later, Bacon and other twentieth-century practitioners articulated the affliction of grief beyond the capability of words: Henry Moore distilled the horrors of war in modernist bronzes such as *Falling Warrior* 1956–7, Paul Nash in oil on canvas works like *Totes Meer (Dead Sea)* 1940–1.

Photography, of course, does something different again. In her introduction to Peter Hujar's *Portraits in Life and Death* (1975), Susan Sontag wrote, 'Photographers, connoisseurs of beauty, are also – wittingly or unwittingly – the recording-angels of death.'[6] I often recall Sontag's words because they remind me that the resonance of a photograph can change over time. For example, in *Jochen taking a bath* 1997, Wolfgang Tillmans captured his boyfriend, the artist Jochen Klein, in the same year that Klein died from AIDS-related complications. And, while it's true that an overly detailed examination of an artist's biography can hinder the work's autonomous agency, it's nonetheless worth considering the political context of their production. Sami, for instance, reckons with a personal relationship to an ongoing conflict, while Merritt operated against a backdrop of gender inequality. (*Love Locked Out* was the first work by a female artist to enter the national collection.) Homosexuality in the UK had been legal for barely five years when Bacon started his *Black Triptychs*; three decades on, Tillmans captured a community devastated by HIV/AIDS. So, despite their superficially innocuous appearance, works such as this and *Love Locked Out* could be perceived as subtle rebuttals to the prevailing norms. A good artist should be a fly in ointment. Even seemingly direct representations, such as *The Fall of Anarchy* or *The Vale of Rest*,

contain secret multitudes that weren't deciphered for decades – or, in the case of Turner's painting, may never be decoded.

I've always understood Tillmans, particularly in his early work, to be interested in haptics: in *Faltenwurf (oliv)* 1996, soft grey denim is threaded through the columns of a ridged Victorian radiator; *Lutz & Alex sitting in the trees* 1992 contains bare fleshy thighs pressed against branches. The artist further disrupted hierarchical notions of display by pinning his vulnerable, unframed prints directly to the gallery walls. In a 2017 interview, Tillmans described himself as 'aware of the fragility of life'[7] – a sentiment, no doubt, felt by many artists mentioned here. Now, as I move through the process of comprehending loss myself, it is precisely such intimate personal photographs – the ones I can hold in my hand or pin to the wall above my desk – from which I take the greatest solace.

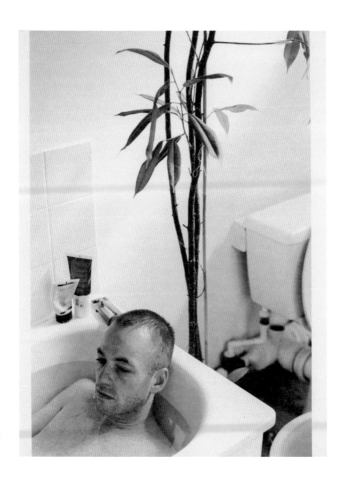

Wolfgang Tillmans, *Jochen taking a bath* 1997, digital print on paper, 40.6 x 30.4, Tate

"SO, DESPITE THEIR SUPERFICIALLY INNOCUOUS APPEARANCE, WORKS SUCH AS THIS COULD BE PERCEIVED AS SUBTLE REBUTTALS TO THE PREVAILING NORMS."

Endnotes

1 'Mohammed Sami in conversation with Sohrab Mohebbi, June 2021', *File Note 144: Mohammed Sami*, exh. brochure, London: Camden Art Centre 2023, https://camdenartcentre.org/file-notes/file-note-144-mohammed-sami#mohammed-sami-in-conversation-with-sohrab-mohebbi-june-2021 (accessed 21 March 2023).

2 John Russell, *Francis Bacon*, 2nd edn., London 1993, p.151.

3 David Sylvester, *The Brutality of Fact: Interviews with Francis Bacon*, 3rd edn., London 1993, p.144. This revised and expanded edition of the book features on its cover a photograph of the artist looking pensive and isolated, in a blazer and thin tie, at his Paris opening in October 1971.

4 Sam Smiles, '*The Fall of Anarchy*: Politics and Anatomy in an Enigmatic Painting by J.M.W. Turner', *Tate Papers*, no.25, Spring 2016, https://www.tate.org.uk/research/tate-papers/25/fall-of-anarchy-politics-anatomy-turner (accessed 21 March 2023).

5 Percy Bysshe Shelley, 'The Masque of Anarchy' (verses viii and ix), in *The Major Works*, London 2003, pp.400–12.

6 Susan Sontag, 'Introduction', in Peter Hujar, *Portraits in Life and Death*, New York 1976.

7 Lou Stoppard, 'Interview: Wolfgang Tillmans', *SHOWstudio*, 10 April 2017, https://www.showstudio.com/projects/in_camera/wolfgang_tillmans (accessed 21 March 2023).